SAN FRANCISCO

THE PAINTED CITY

SAN FRANCISCO

THE PAINTED CITY

Harvey L. Jones

SALT LAKE CITY

First edition
97 96 95 94 93 5 4 3 2 1

This is a Peregrine Smith Book, published by Gibbs Smith, Publisher
P.O. Box 667, Layton, Utah 84041

Book design by Kathleen Timmerman

Bridge icon by Alex Boies

On the jacket, *San Francisco Cable Car Celebration*, by Lee Blair

Printed in Hong Kong

Library of Congress Cataloging-in-Publication Data

Jones, Harvey L.
 San Francisco: the painted city / Harvey L. Jones. —1st edition
 p. cm.
 ISBN 0-87905-481-6
 1. San Francisco (California) in art. 2. Painting, Modern—19th century.
 3. Painting, Modern — 20th century. 4. San Francisco (California)—History.
 I. Title. II. Title: Painted City.
ND1460.S24J66 1993
758'.997494461—dc20 92-33549
 CIP

In olden days, a child, I trod thy sands,
 Thy sands unbuilded, rank with brush and briar
And blossom—chased the sea-foam on thy strands,
 Young City of my love and my desire.

I saw thy barren hills against the skies,
 I saw them topped with minaret and spire;
Wall upon wall thy myriad mansions rise,
 Fair City of my love and my desire.

With thee the Orient touched heart and hands,
 The world-wide argosies lay at thy feet;
Queen of the queenliest land of all thy lands—
 Our sunset glory, regal, glad, and sweet!

I saw thee in thine anguish tortured! prone!
 Rent with the earth-throes, garmented in fire!
Each wound upon thy breast upon my own,
 Sad City of my grief and my desire.

Gray wind-blown ashes, broken, toppling wall
 And ruined hearth—are these thy funeral pyre?
Black desolation covering as a pall—
 Is this the end—my love and my desire?

Nay! strong, undaunted, thoughtless of despair,
 The Will that builded thee shall build again,
And all thy broken promises spring more fair,
 Thou mighty mother of as mighty men.

Thou wilt arise, invincible! supreme!
 The world to voice thy glory never tire;
And song, unborn, shall chant no nobler theme—
 Great City of my faith and my desire.

But I will see thee ever as of old!
 Thy wraith of pearl, wall, minaret and spire,
Framed in the mists that veil thy Gate of Gold—
 Lost City of my love and my desire.

—Ina Coolbrith

CONTENTS

OR NEARLY ALL OF its illustrious history San Francisco has enjoyed a substantial reputation among great cities of the world which seems disproportionate to its relatively small size and its scant 150 years of existence.

As news of the California Gold Rush of 1849 flashed around the world, San Francisco became a magnet for adventurous and imaginative people from all parts of the globe. California's first seaport received shiploads of gold seekers after their long journey around Cape Horn or across the Isthmus of Panama. San Francisco developed with wild abandon, inventing itself along the way.

Numbered among the early arrivals were many artists. Unsuccessful in the gold fields, they came back to the city where they began to pursue portrait commissions from the new millionaires or find some other commercial application for their talents. Charles Christian Nahl and his half brother, Hugo Wilhelm Arthur Nahl, arrived from Germany and soon abandoned the mines in favor of their artistic careers. Ultimately, they became California's pre-eminent gold rush painters and illustrators. Other pioneer painters of San Francisco included Thomas Ross and George Henry Burgess, whose images give a vivid picture of life in the rough-and-tumble metropolis. As gold fever subsided, the wilderness area of northern California attracted professional landscape painters from

Europe and the eastern United States who had received news of its spectacular topography and dramatic pictorial potential.

In the 1860s, dozens of itinerant artists paid visits to San Francisco, where they maintained studios in between extended sketching trips to the mountain wilderness. Major talents such as Albert Bierstadt, Thomas Moran, and Thomas Hill found inspiration in the scenic grandeur of Mount Shasta, the Yosemite Valley, and other sites along the Sierra Nevada Range.

San Francisco soon developed a substantial community of resident painters who found patronage among its wealthy citizens. Millionaire railroad, merchant, and banking tycoons built their opulent mansions atop San Francisco's Nob Hill, and furnished them, in the height of Victorian taste, with collections of ornately framed California paintings. Portrait and landscape subjects remained popular, but immigrant artists such as Fortunato Arriola, Edwin Deakin, Joseph Harrington, William Coulter, William Hahn, and Marius Dahlgren formed a growing nucleus of painters who catered to a ready market with genre scenes and town views depicting the more genteel and prosperous neighborhoods.

In 1871, a group of painters and art patrons founded the San Francisco Art Association to provide for regular public exhibitions. Three years later, the association established its California School of Design, the only academy of art west of Chicago. The vitality of this local art scene continued to attract artists from afar during the 1870s, and fostered the emergence of the first generation of San Francisco-born painters in the 1880s and 1890s. Charles Rollo Peters, Theodore Wores, Clarksen Dye, Henry Alexander, and Lucia Kleinhans Mathews were some of the city's most accomplished natives who polished their initial art training in Europe before resuming local careers.

A severe economic depression during the 1880s greatly undermined the art market and drove many painters—and other inhabitants—to abandon the city. Those who remained continued to find inspiration among San Francisco's impressive array of picturesque attractions and breathtaking vistas. The ruins of historic Mission Dolores, the architectural splendors of Nob Hill, the bustling waterfront activities, exotic Chinatown, the infamous Cliff House, and the curiosities of Woodward's Gardens—all helped create a cosmopolitan atmosphere distinct from any other city in the American West.

The prevailing painting style of the period before the turn of the century was descriptive realism influenced by German and Italian academic standards of accurate draughtsmanship and color observation. San Francisco's artists began to look beyond the geographical isolation of their western outpost, sharing in the optimism and economic recovery of the Gay Nineties. Exposure to recent trends in European art, particularly in France, led to enthusiastic experimentation. A new emphasis on "art for art's sake" brought a higher level of sophistication to painting in San Francisco. The French Barbizon influence emphasized painting directly from nature with spontaneous brush strokes applied in muted color harmonies. The lessons of James McNeil Whistler's carefully organized compositions, arranged in a subdued palette of gray tones, were embraced by San Francisco's own dominant artist of the period, Arthur Mathews. Director of the School of Design from 1891 to 1906, he taught many of California's most prominent painters of the first half of the twentieth century. His wife, Lucia, and painters Xavier Martinez and Rinaldo Cuneo were among his students. As muralist, designer, and teacher, he exerted considerable influence over the city's visual arts activities for three decades.

In the last decade of the nineteenth century, San Francisco had become a true "Metropolis of the West," the eighth largest city in the nation. Its commercial and financial establishments dominated the market for manufactured goods, imports, and exports while its educational and cultural institutions, including twelve daily newspapers, led the region. Alfred Farnsworth, a watercolorist employed by one of those newspapers, often illustrated scenes of San Francisco and its cultural life in this period.

Just as the California Gold Rush of 1849 marked the beginning of the first epoch in San Francisco history, so then did the events of April 18, 1906, mark its end. The near total destruction of the city by earthquake and fire not only drastically altered San Francisco's appearance but also slowed its economic progress. The city was nevertheless rebuilt at a rapid pace, even by today's standards; new buildings soon replaced rubble in the downtown area. The newly constructed blocks were conservative in design but substantial in quality. Although much of its early history had been lost, the new San Francisco maintained its unique character and appeal.

Still, the Mark Hopkins Art Institute had burned, San Francisco's artists had been driven from their demolished studios, and much of their accumulated work had been destroyed. Edwin Deakin was one of many artists who attempted to record in paint on canvas the ordeal and the aftermath of the great earthquake and fire. Arthur Mathews designed the first of the artist's studios to be built after the fire, which he shared with landscape painter William Keith. Many other artists resumed their careers outside the city—in Monterey or in the East Bay towns.

The Panama Pacific International Exposition in 1915 served as a dual celebration of the opening of the Panama Canal and the recovery of San Francisco. It was one of the nation's most successful cultural events and it re-established the reputation of San Francisco as a world-class city. Lucia Kleinhans Mathews and Colin Campbell Cooper were two of many painters who found appealing subjects at the exposition. Emerging San Francisco modernists were encouraged by the vast displays of international paintings they and the general public saw at the P.P.I.E.

These influences can be seen in the works of painters such as Otis Oldfield, Rinaldo Cuneo, and the young Chinese-born painter, Yun Gee. Their pictures of the city express a new vibrancy derived from exposure to French post-Impressionist color and brushwork and to the more radical European modern movements of Cubism and Italian Futurism. San Francisco's rapid economic growth and the corresponding building boom of the 1920s was accompanied by growth of visual arts institutions as well. The city's new museums and art galleries exhibited progressive works by local painters along with the masterworks of international artists.

During the Great Depression in the 1930s, San Francisco seemed to fare better than many American cities. The banks remained stable and the white-collar workers maintained a higher level of employment than elsewhere. But among blue-collar workers unemployment was high, leading to organized labor problems which culminated in the city's violent general strike of 1934. San Francisco emerged from the bloody battles as one of the most unionized cities in the nation.

With a great boost from federally sponsored public works programs, San

Francisco entered a decade of civic construction that created many jobs and built a number of the city's cultural monuments and its two great bridges. The creation of decorative murals and sculptures for several new public buildings throughout the city occupied the talents of its artists. Coit Tower atop Telegraph Hill provided employment for twenty-six local artists, among whom were John Langley Howard, Rinaldo Cuneo, and Otis Oldfield. Depicting the American scene, painted in fresco, and strongly influenced by the style of famed Mexican muralist Diego Rivera, the murals sparked a controversy for the social criticism implied in some of the panels.

The years between the 1920s and 1950s in California saw a resurgence of interest in watercolor as a medium for representational painting. Broad gestural brush strokes with vibrant translucent colors, executed directly on paper with little or no preliminary drawing, became a popular method of depicting rural and urban scenes of everyday life. San Francisco's picturesque streetscenes, with their many famous icons, inspired watercolorists such as Lee Blair, George Post, Rex Brandt, and Dong Kingman to seek out unfamiliar viewpoints from which to create fresh, clear images that captured the buoyant spirit of the city.

World War II thrust the San Francisco Bay Area onto the world stage. Its strategic Pacific-coast location made it a hub for navy and army operations, troop movement, and ship building. The city's population swelled with the arrival of workers employed by the various wartime industries. In the summer of 1945, the city hosted a conference which resulted in the signing of the United Nations charter in a ceremony at the War Memorial Opera House.

In the postwar years, as former military personnel and defense workers settled permanently in San Francisco, the population continued to grow until it reached an all-time high of over 775 thousand in 1950. The city's international character was reinforced by continual waves of immigrating Hispanic and Asian populations as well as newly arriving African Americans from all parts of the nation. Many of the changes brought about by growth were also reflected in San Francisco's art and entertainment activities. The influx of multi-cultural groups brought a broader perspective and a variety of new interests to the local scene. One could find virtually every kind of popular entertainment and nightlife from

jazz or blues music to Italian opera or flamenco dancing; from go-go dancers to female impersonators along a few blocks of glittering, noisy, neon-lighted Broadway in North Beach.

The postwar visual arts, especially progressive painting, made a radical turn away from realism to abstract expressionism as it was practiced by the experimental faculty and students at the California School of Fine Arts (now called the San Francisco Art Institute) on Chestnut Street. A dynamic group of painting teachers from New York and California including Clyfford Still, Mark Rothko, Ad Reinhart, David Park, Elmer Bischoff, and Richard Diebenkorn, among others, brought national attention to San Francisco's "action painters."

After 1950, a number of Bay Area abstract painters, led by David Park and Elmer Bischoff, reintroduced representational and figurative subject matter into their expressionist works. The Bay Area Figurative Style that followed is regarded as a truly original West Coast school of painting.

The spontaneity of expression in painting at the time had an affinity with the poetry, jazz, and literature that was a part of San Francisco's so-called Beat Generation during the 1950s. Figures like Jack Kerouac, Allen Ginsberg, Gary Snyder, and Lawrence Ferlinghetti formed the heart of the Beat scene. Its followers inhabited North Beach coffeehouses dressed in turtleneck sweaters, sandals, berets, and dark glasses. The Beat phenomenon was a great source of curiosity for tourists until the Hippie was born in the 1960s.

By 1967 during San Francisco's celebrated Summer of Love, a once fine Victorian-era residential district located near the intersection of Haight and Ashbury streets, adjacent to the Panhandle of Golden Gate Park, had been appropriated by throngs of hippies dressed in their funky, thrift-shop garb adorned with peace symbols and beads. Hippies actively demonstrated against the Vietnam war, enthusiastically embraced rock music, and flaunted their uninhibited experimentation with free sex and mind-expanding drugs, but they scarcely outnumbered the busloads of gaping tourists who visited this latest San Francisco attraction.

Some of the city's artists of the 1960s and 1970s expressed a visual equivalent of hippie philosophy in subjective paintings with psychedelic and visionary

imagery. Still others revived an interest in objective realism. Artists such as Charles Griffin Farr, Wayne Thiebaud, and Paul Wonner brought their well practiced perceptions and painterly skills to bear upon many familiar objects and places. When San Francisco provided the subject matter, their paintings revealed fresh insights to the city's magnetism.

Another approach to contemporary realism capitalized on the uncompromising objectivity of the camera lens in a painting style known as photo-realism. Robert Bechtle and Willard Dixon are two who re-create commonplace scenes of the city as they would appear in greatly enlarged and somewhat artless color snapshots. Their virtuoso painting techniques convey the sensual pleasures of light and shadow in factual depictions of unsentimental urban scenes; they also seem to reflect a certain practical component in San Francisco's personality—its conservative banker's side—that helps offset its strong romantic impulse.

In the past two decades, San Francisco Bay Area art has flourished without the apparent dominance of a single vanguard movement or style. This eclecticism allows painters to borrow from the past and combine various forms of visual arts expression. Individuals may identify their work as "new expressionist," "postmodern," or representative of this or that "ism," which is more often an artist's personal concept than that of a cohesive group or school. This artistic pluralism is a reflection of the times: modern life provides ready access to the ideas and products of the entire world.

In their realist depictions of present-day San Francisco, Yvonne Jacquette, Larry Morace, Peter Nye, and Larry Cohen have used photographic images of the city as a point of departure for their individual painterly interpretations featuring traditional techniques.

San Francisco's cosmopolitan profile today is more diverse and complex than ever before. Its commitment to the past is evident in the preservation projects that are sometimes challenged by change or expansions. The painters of San Francisco will continue to reflect its beauty and vitality as the city struggles to assimilate change gracefully while maintaining the best of its history and traditions.

—Harvey L. Jones
Oakland, California

A N ENDURING FEATURE of San Francisco's architectural heritage is the Victorian row house designed to fit the city's typically narrow 25-by-100-foot lot. Resourceful architects and builders from the 1870s through the 1890s created wood-frame houses of two or three stories with flamboyant "gingerbread" ornamentation of the façades in a form known as Carpenter's Gothic. Bay windows were often employed to maximize floor space, natural light, and ventilation.

The interiors of these Victorian homes—especially those owned by wealthy San Franciscans—were furnished with heavy carpets and draperies, upholstered horse-hair divans and chairs, gilt-framed paintings and mirrors, bric-á-brac, and objects d'art. Victorian taste seemed to decree "too much is never enough."

Henry Alexander (1860–1894), a San Francisco-born, Munich-trained painter of meticulously detailed interiors, celebrates such a parlor of the privileged in *Teete's House*. That it is inhabited only by the small dog on a cushion lends a disconcerting quality to this lush scene which is indicative of the artist's reputation for personal eccentricity.

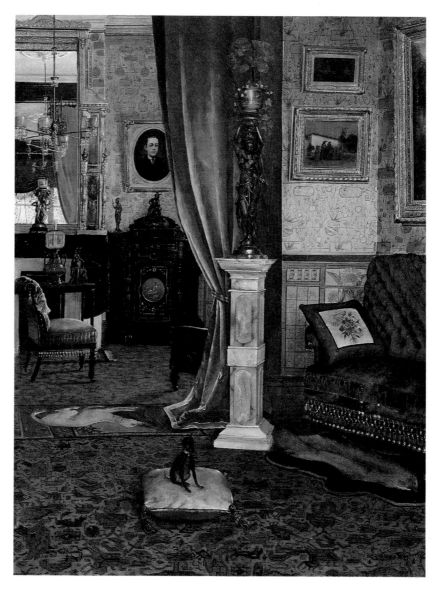

TEETE'S HOUSE
Henry Alexander, 1886, oil on canvas, 28 3/8 x 21 1/8 inches.
University Art Museum, University of California, Berkeley
(Bequest of Hannah N. Haviland). Photo by Ben Blackwell.

 DISTINCTIVE FEATURE of San Francisco's climate, not common to most other California cities, is the regular arrival of a cooling marine fog at the end of a warm summer day. Low-lying clouds of fog flow inland from the ocean, entering through the Golden Gate or spilling over the high coastal hills, and engulfing much of the city.

Fortunato Arriola (1827–1872), a Mexican-born artist, was a respected painter in San Francisco until his untimely loss in a ship burned at sea. His 1865 painting, *Howard Street, Evening*, captures the mysterious atmospheric effects on a foggy nocturnal street in San Francisco.

A horse-drawn streetcar and a liveried coach are silhouetted against the evening sky. Dimly illuminated by street lamps and coach lanterns, they move east on Howard Street, from Fourth to First streets, past several prominent public buildings and private residences. The Selby Shot Tower, where small shot for sporting guns was cast, can be seen at the end of the street where it was then a major landmark on the city's skyline, much as Coit Tower and the Transamerica pyramid are today.

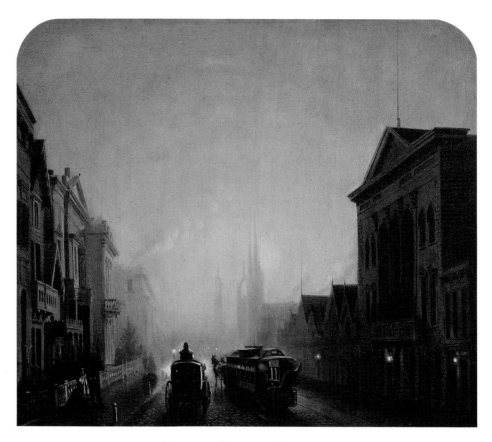

HOWARD STREET, EVENING
Fortunato Arriola, 1865, oil on canvas, 18 x 24 inches.
Collection of Dr. Albert Shumate, San Francisco.
Photo by M. Lee Fatherree.

A S SAN FRANCISCO'S population grew to its all-time high in 1950, new residential neighborhoods were being built along the outer reaches of the city. To accommodate postwar, working-class families, large tract housing developments featuring one-story, single-family dwellings, sprang up in the areas southwest of downtown. The automobile made a conspicuous impact on these residential neighborhoods: manicured lawns, divided by driveways, bordered the broad streets.

Robert Bechtle (b. 1932) is a San Francisco artist with an important national reputation as a photorealist. He is well known for his paintings of automobiles in urban California settings, such as this Ocean Avenue street scene.

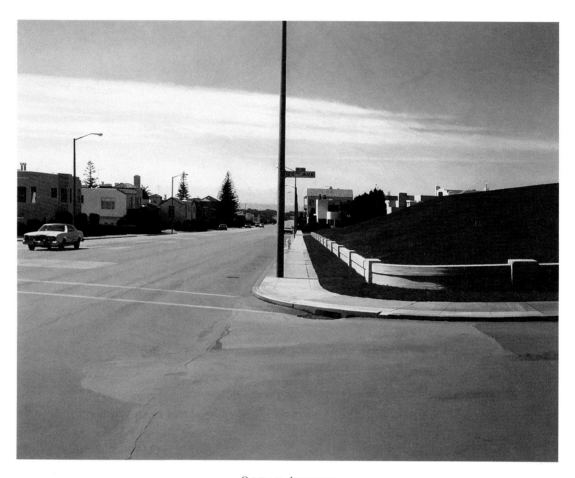

OCEAN AVENUE
Robert Bechtle, 1987, oil on canvas, 40 x 50 1/2 inches.
Collection of Pacific Telesis Group, San Francisco. Photo courtesy of OK Harris Gallery, New York.
Pboto by D. James Dee.

*S*AN FRANCISCO'S CELEBRATED nightlife offers something to appeal to every taste— from mild to wild. Musical entertainment runs the gamut. In theaters, nightclubs, cabarets, and cafés, enthusiastic audiences applaud the talents of local performers as well as star roadshow attractions.

Historically, blues musicians and singers have found a devoted following in the city. Sugar Hill, on Broadway, was the first room in San Francisco dedicated to the blues. Posh salons, such as the Venetian Room of the Fairmont Hotel, can boast that they have presented some of the very best of America's blues singers over the years.

Elmer Bischoff (1916–1991), an artist who was also an amateur musician, is nationally recognized as one of the originators of the Bay Area figurative style of painting. His emotionally charged images, derived from recollected or composite experiences, are created in broad, flowing brush strokes.

In Bischoff's *Blues Singer*, the idiosyncratic choice of color conveys a sense of theatrical lighting on the tented stage and heightens the telling gestures of the performer.

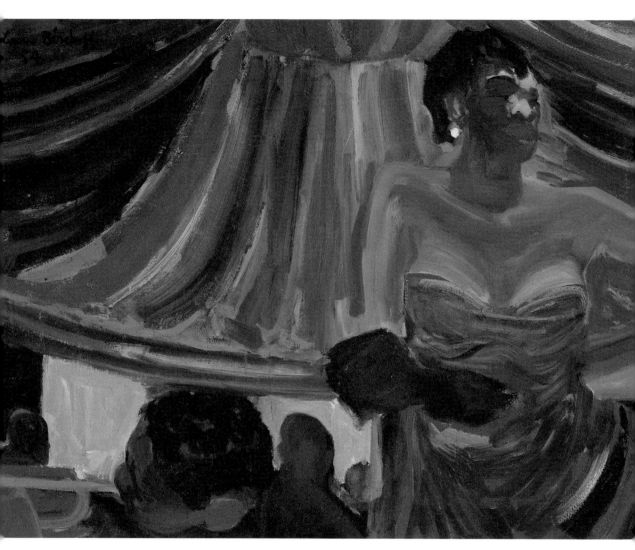

BLUES SINGER
Elmer Bischoff, 1954, oil on canvas, 55 x 72 inches.
Collection of The Oakland Museum.

*F*OR MORE THAN a hundred years, cables have clattered beneath the steep streets, accompanied by the rhythmic clanging of cautionary bells. The cable cars are more than a quaint form of transportation in a modern city, they have become the virtual trademark of San Francisco.

Motivated by his humanitarian concern for the horses who had to be beaten to pull carriages up San Francisco's hills, Andrew Hallidie invented the passenger cable car system in 1873, applying his knowledge of the cable transport devices used in mines. During a peak period in the 1880s, eight different lines were in operation, extending 112 miles throughout the city; today three lines cover a distance of only nineteen miles.

Los Angeles native Lee Blair (b. 1911), was a director of color and animation for Walt Disney Studios in the 1930s, where he worked on *Pinocchio*, *Bambi* and *Fantasia*. Blair's watercolor of a San Francisco cable car cresting a precipitous hill, as city lights twinkle in the purple dusk, has a lively animated quality to match the mood of the spirited celebrants on the car and the street corner.

SAN FRANCISCO CABLE CAR CELEBRATION
Lee Blair, 1938, watercolor on paper, 15 x 21 1/2 inches.
Collection of Sally and David Martin, Santa Barbara.

*F*OR 150 YEARS, men talked of bridging the Golden Gate. That mile of space defines the only place on the continent where the Pacific Ocean breaches a coastal mountain range. Twice daily the force of the sea pours through at flood tide, and twice more the waters of the 50-mile-long San Francisco Bay ebb out at a volume twice the average flow of the Mississippi. The prospect of sinking foundations for a bridge in such currents—in enough depth to swallow a 30-story building—seems impossible enough. But the Golden Gate also funnels weather: blinding fog and raging gales are commonplace. Maverick engineer Joseph Strauss finally got the money to build the bridge, but only after a protracted philosophical, legal, and political battle.

The Golden Gate Bridge, opened in 1937, is the city's most enduring symbol. Suspended from wire cables stretched between two main towers, the single deck supports six lanes of vehicular traffic and pedestrian walkways, connecting San Francisco with the northern counties. Its distinctive "international orange," chosen by principal designer Irving Morrow, complements the reddish rock of the Marin cliffs, contrasts pleasingly with the brown or green of the distant hills, and shines through the persistent marine fog. The paint is resistant, but not impervious, to wind and saltwater, so the bridge is perpetually being repainted.

Rex Brandt, born in 1914 in San Diego, received his art education in California, and there became a leading exponent of watercolor in the regionalist style of landscape painting. His brightly romantic Golden Gate, with long fingers of cool grey fog crossing the bridge above a bay dotted with sailboats, represents a view still visible on any given day.

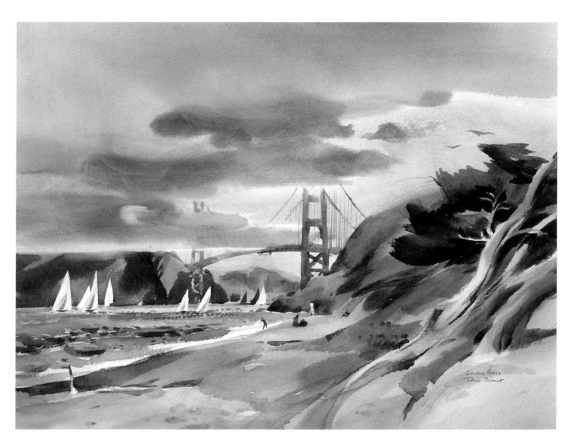

THE GOLDEN GATE
Rex Brandt, not dated, watercolor on paper, 20 5/8 x 27 1/2 inches.
The Buck Collection.

FTER THE DISCOVERY of gold at Sutter's Mill near Sacramento in 1848, San Francisco became the first port of entry for the vast migration which ultimately made California the nation's most populous state.

The gold rush transformed a small commercial village into a bustling city. By the fall of 1849, the population of San Francisco had grown from 800 to 35,000—a volatile mixture of peoples, languages, and cultures. Hundreds of ships, abandoned by gold seekers and crews, rotted in the harbor. Builders scrambled to put up permanent houses, hotels, shops, saloons, and warehouses along dusty or muddy streets amid the rickety shacks and tents belonging to miners, merchants, carpenters, clerks, cooks, and gamblers.

In 1891, London-born artist George Henry Burgess (1831–1905) completed this panoramic painting of San Francisco as it looked in 1849. The view, re-created with the aid of images and documents supplied by resident eyewitnesses, centers on Montgomery Street in the present-day financial district. Telegraph Hill can be seen in the distance. From its heights, notice of ships entering the Golden Gate was signaled to merchants in the town.

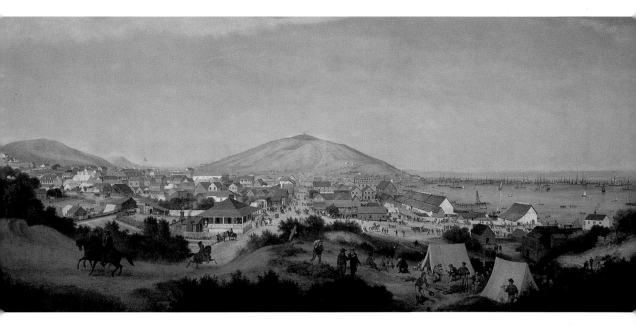

SAN FRANCISCO IN JULY, 1849
George Henry Burgess, 1891, oil on canvas, 62 x 132 3/4 inches.
Collection of The Oakland Museum (Gift of the Women's Board, Oakland Museum Association).
Photo by M. Lee Fatherree.

ITH ITS DISTINCTIVE skyline comprised of tall buildings, multiple bridge towers, and high-density architecture covering the steep hillsides, San Francisco epitomizes a metropolis. However, when compared to other great cities of the world, it is relatively small: only 724 thousand people live in an area covering just 48 square miles. The combination of big-city attractions and small-city advantages make San Francisco the favorite of so many of its visitors, who, in turn, make tourism San Francisco's chief industry.

Larry Cohen (b. 1952) is a contemporary painter known for his realistic urban scenes rendered in carefully controlled bravura brush strokes. San Francisco is complex—shaped by momentous events in its brief history, by its special geography, and by the cultural diversity of its people—but in this distant view of downtown, Cohen captures the simple visual allure of a sunlit city in the sparkling clarity of a breezy afternoon.

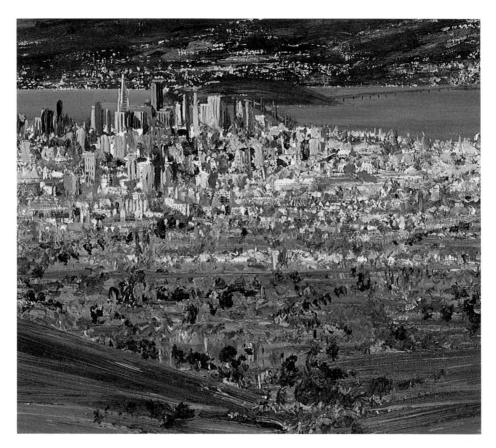

DOWNTOWN SAN FRANCISCO
Larry Cohen, 1990, oil on canvas, 17 x 20 inches.
Courtesy of John Berggruen Gallery, San Francisco.

*T*HE MARINA DISTRICT, running alongside the bay north of Pacific Heights, is built on marshy land filled in for the Panama Pacific International Exposition of 1915. Sole survivor of that fair, the Palace of Fine Arts stands at the western edge of the Marina. At the exposition, its 72 galleries held more than 7500 works of art from around the world, and brought many geographically isolated Californians their first glimpse of such major European art movements as Impressionism, post-Impressionism, and Futurism.

Bernard Maybeck's domed octagonal rotunda, surrounded by a semicircular double colonnade, has the ambience of a great Roman ruin, magnified by reflections in the ornamental lagoon. Cooper's painting preserves the theatrical effects created by concealed floodlights at the P.P.I.E. The original palace was, in fact, a stucco stage set, meant to be demolished at the conclusion of the exposition. But San Franciscans could not bring themselves to do it. In 1962, using public monies and a philanthropic gift, the palace was rebuilt in concrete. It now houses a hands-on science museum, a theater, and an art gallery.

Colin Campbell Cooper (1856–1937) was born in Philadelphia and studied at the Pennsylvania Academy and at Académie Julian in Paris. He painted in New York for twenty years, executing street scenes and architectural subjects in an impressionistic style. After 1921, Cooper made his home in Santa Barbara.

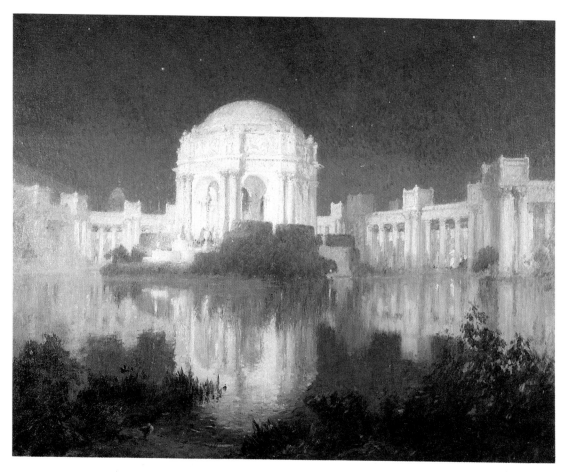

THE PALACE OF FINE ARTS
Colin Campbell Cooper, 1916, oil on canvas, 40 1/2 x 50 inches.
Collection of the Crocker Art Museum, Sacramento (Gift of Miss Helen Seeley
in memory of Mr. and Mrs. Colin Campbell Cooper).

FAVORITE RENDEZVOUS for uninhibited fun-seekers in the Victorian era—those bent on a night of revelry away from the disapproving eyes of San Francisco's more virtuous citizens—was the notorious Cliff House. This well-known resort was located on a cliff overlooking the Pacific Ocean (and the famous Seal Rocks) at the far western edge of the city.

Visitors made the five-mile trip in stylish horse-drawn buggies, on bicycles, or via the steam railroad that served the area before the advent of the motorcar. They came to watch the antics of sea lions on Sunday afternoons and they came to wine and dine the demimonde in discreetly curtained parlors at night.

The Irish-born painter William Coulter (1849–1936), who for 65 years documented the era of sailing ships on San Francisco Bay, depicted the second of five Cliff House structures that have graced the site since 1861. Cliff House burned down three times and once exploded from a secret cache of dynamite stored on the premises, whereupon some of San Francisco's clergymen declared that divine retribution was responsible for the destructions. Today's Cliff House restaurant no longer bears the stigma of wild parties, but its scenic vistas are unparalleled and it still draws a crowd.

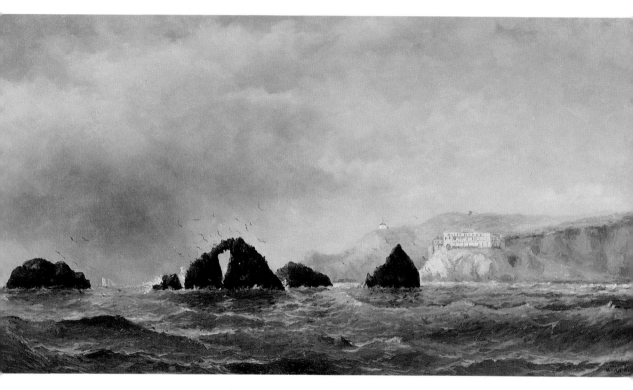

CLIFF HOUSE AND SEAL ROCKS
William Coulter, 1876, oil on canvas, 18 1/4 x 34 1/4 inches.
Private Collection. Photo courtesy of North Point Gallery, San Francisco.

ROM A DISTANCE, San Francisco has always resembled the hill cities of the Mediterranean. Most of its structures are painted in creamy pastels which reflect the hazy sunlight, and contrast with the blue of the bay and the golden hills beyond. In the twenty years between the two world wars, urban growth fueled civic improvements. This quantitative measurement of progress justified an acceleration in construction projects, an effort to ensure San Francisco's place among the world-class cities—a rival to its European antecedents.

Rinaldo Cuneo (1877–1939), whose family came in the first wave of Italian settlers to reach the Bay Area in 1848, was called "the painter of San Francisco." Cuneo sought out unusual corners of the city and often climbed to high elevations for new viewpoints to inspire his paintings. His painting, *San Francisco from Twin Peaks* captures the optimistic spirit of a growing city as a Cézannesque patchwork of interlocking geometric shapes in high-key colors.

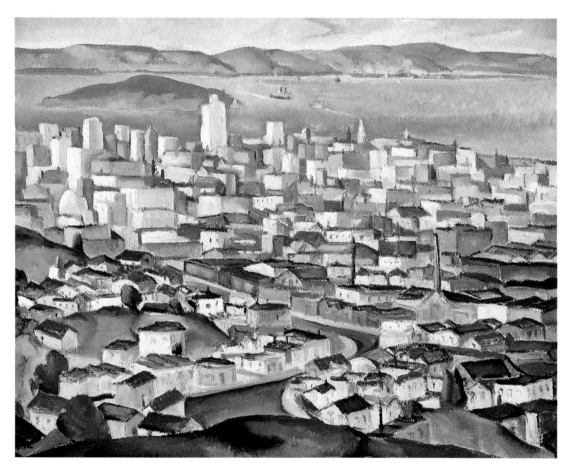

SAN FRANCISCO FROM TWIN PEAKS
Rinaldo Cuneo, not dated, oil on board, 16 x 20 inches.
Collection of Mr. and Mrs. Brayton Wilbur, Jr.
Photo courtesy of William A. Karges Fine Arts, Carmel and Santa Monica.

HIS SMALL ISLAND in the bay was originally named for the goats that once grazed on the wild grasses and the white-flowering wild mint that grew along its steep slopes. The longest tunnel of its type in the world now bores through the center of the island—long since re-christened *Yerba Buena* (Spanish for "good herb")—and connects the double-decked suspension and cantilevered spans of the San Francisco-Oakland Bay Bridge.

To enlarge the land available for the 1939 Golden Gate International Exposition—a world's fair celebrating the Golden Gate and Bay bridges—a 400-acre portion of the bay adjacent to Yerba Buena island was filled in. Treasure Island, so named because it was assumed that land-fill dredged from the bay might contain particles washed down from the forty-niner gold fields, has remained a U.S Naval installation since the exposition closed at the beginning of World War II.

Marius Dahlgren (1844–1920) studied at the Royal Academy in his native Denmark before joining his artist brother, Carl, in San Francisco in 1878. Dahlgren's *View From Goat Island* depicts the variety of marine activity—fishing, freight hauling, and passenger transport—that was integral to the life of the city in the days before railroads and highway systems. His painting shows net-fishing from rowboats; two schooners under sail; and a tugboat towing a bark as a rainstorm passes over the bay. Mt. Tamalpais, Angel Island, and Alcatraz Island—in 1887 occupied as a military fort and lighthouse—are notable landmarks in the background.

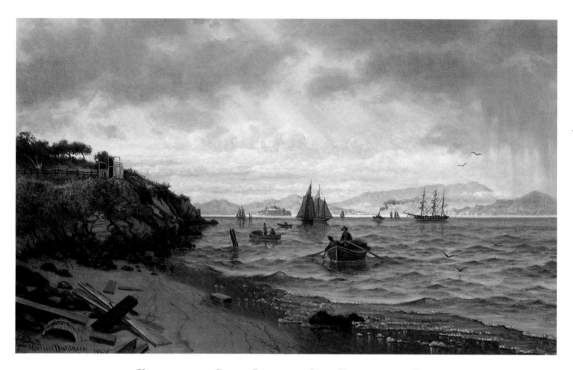

VIEW FROM GOAT ISLAND, SAN FRANCISCO BAY
Marius Dahlgren, 1887, oil on canvas, 30 1/2 x 50 inches.
The Oakland Museum's Kahn Collection.

*T*HE OLDEST AND most important remaining landmark structure in the city dates from the Spanish period in California when the area was called Yerba Buena. The name was not officially changed to San Francisco until 1847. Mission San Francisco de Asis was established in 1776 at its present location near a stream-fed lagoon called *Laguna de los Dolores*, from which it derives its popular name—Mission Dolores. The current chapel, built in 1791 and restored in 1917, survives its various attachments and outbuildings no longer extant.

Edwin Deakin (1838–1923) was born in England, but settled in San Francisco in the 1870s where he was a successful painter of landscapes, still lifes, and architectural views. He traveled up and down California's coast between 1870 and 1899, seeking to document each of the twenty-one original missions. Deakin found many of the buildings in a badly deteriorated condition, but he painted them as he imagined they originally looked. Today the chapel and old cemetery share the site with a basilica built in 1913 and remodeled in the 1920s.

MISSION SAN FRANCISCO DE ASIS
Edwin Deakin, 1895, oil on canvas, 36 x 54 inches.
Collection of the Natural History Museum of Los Angeles County.
Photo courtesy of Seaver Center for Western History Research.

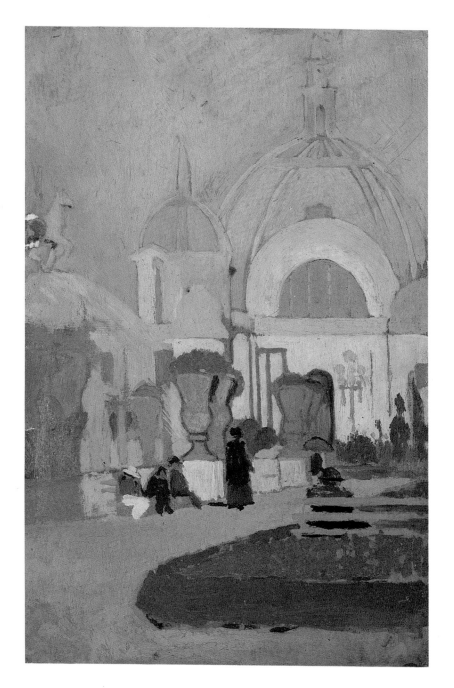

THE PAINTED CITY

*T*HE CATASTROPHIC EARTHQUAKE that struck at 5:12 on the morning of April 18, 1906 marked the end of a golden era in the history of San Francisco. Damage to the city caused by the massive quake on the San Andreas fault was compounded by a disastrous conflagration that raged out of control for three days when severed water mains hampered the firefighting efforts. Further damage resulted when buildings were blown up to help control the spread of the fire.

More than 28,000 buildings in business and residential areas covering 514 city blocks were reduced to ashes, leaving two-thirds of San Francisco's residents homeless. Displaced families set up temporary camp in city parks beyond the fire districts during the recovery period.

Edwin Deakin, by then a prominent San Francisco painter, had recorded the course of the great fire in a number of small oil sketches made from a distant vantage point in the East Bay hills. He returned to the city to capture on canvas a larger image of the smoldering ruins he called *Despair*. In Deakins's painting we see the broken steps and smoking rubble of a once-fine Nob Hill residence overlooking a demolished San Francisco Civic Center, its landmark dome still standing over a collapsed City Hall.

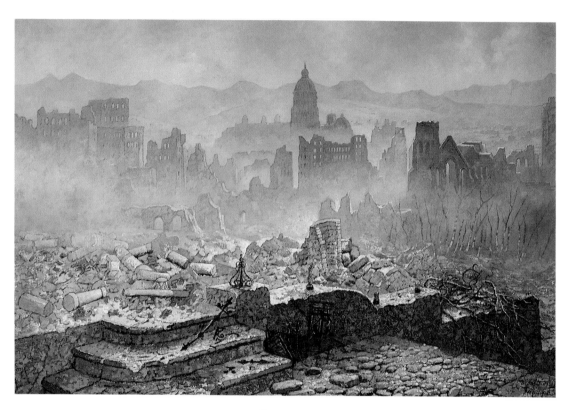

DESPAIR
Edwin Deakin, 1906, oil on canvas, 28 x 42 1/4 inches.
Collection of The Oakland Museum
(Gift of Mr. and Mrs. Howard Willoughby).

MONG SAN FRANCISCO'S appealing amenities are the more than 150 parks and recreation areas scattered throughout the city. On almost any afternoon, joggers and cyclists take to the paths and roadways along miles of beautifully landscaped greenspaces, while families and friends gather on the acres of well-kept park lawns for picnics or games of softball and Frisbee.

Willard Dixon (b. 1942), earned his graduate degree in painting at the San Francisco Art Institute. Dixon is best known for his large-scale realist paintings of California landscapes and urban scenes; this panoramic view of Dolores Park overlooks the city skyline from a Mission District hillside. The clear objectivity of his highly detailed representation is further enhanced by his atmospheric lighting effects, so typical of San Francisco's Pacific sky.

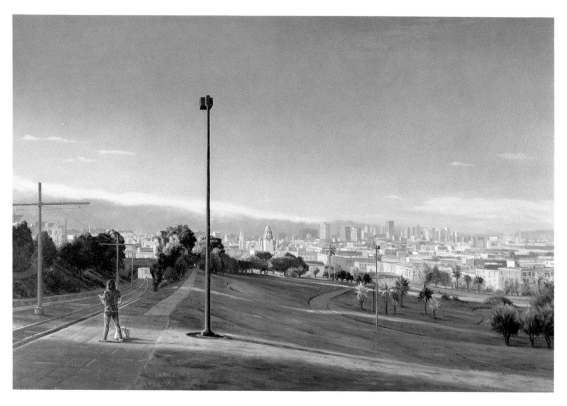

DOLORES PARK
Willard Dixon, 1988, oil on canvas, 48 x 72 inches.
Collection of Bell Atlantic Corporation (Photo courtesy of
Contemporary Realist Gallery, San Francisco).

NE OBVIOUS ADVANTAGE of dwelling in a city built on many hills, near a body of water, is that it may be possible—with some money and a little luck—to find a home with a pleasing view. In addition, San Francisco's temperate climate supports a great variety of vegetation year round. Beautiful gardens and spectacular vistas still characterize the city as they did in Clarksen Dye's time.

Dye (1869–1955), a San Francisco artist known for his scenes of the city, painted this atmospheric early-morning view of the bay from his hillside home. A tall, languidly graceful Eucalyptus tree is prominent in the picture. Appreciated for its aesthetic qualities and its pungent fragrance, this Australian native is one of many imported plants that has flourished in California's coastal regions.

FROM MY WINDOW, OCTOBER 1, 1905
Clarksen Dye, 1905, oil on canvas, 20 x 12 inches.
Collection of Oscar and Trudy Lemer.

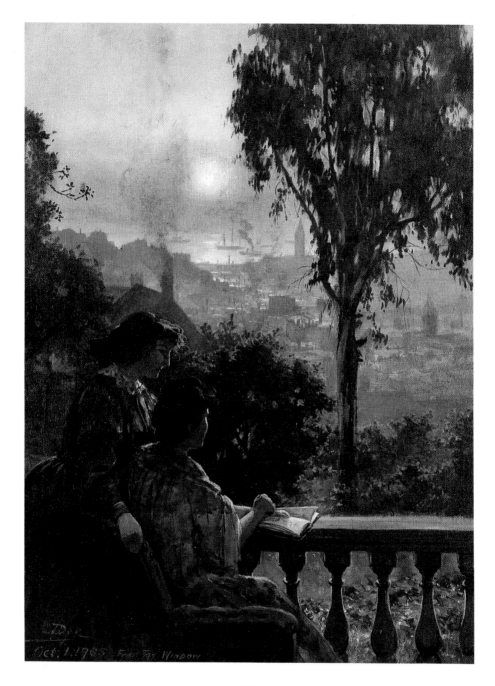

THE PAINTED CITY

*T*HE CULTURAL ASPIRATIONS of San Francisco were in evidence very early when celebrated performers played to saloon audiences of rowdy miners just back from the gold fields. Later on, international stars of the lyric stage were presented to patrons of growing sophistication in a number of newly built theaters and opera houses. San Franciscans saw their first staged opera, Bellini's *La Sonnambula*, in 1851. Thus began the city's enduring fascination with that complex and extravagant art form and its attendant social customs.

In the gaslight era, San Francisco's Tivoli Opera House began as a beer garden with musical entertainment in the 1870s and evolved to become the city's most beloved musical theater. For many years before it burned to the ground in 1903, and after it was rebuilt at another site, its stock company gave nightly performances of operetta and grand opera for an audience seated at tables in luxurious surroundings.

Alfred Farnsworth (1858–1908), an English-born watercolorist, is best known for his scenes in and around San Francisco at the turn of the last century. His *Tivoli Opera House* depicts a group of fancy dress "first nighters" leaving the theater at its Sutter Street location.

TIVOLI OPERA HOUSE
Alfred V. Farnsworth, ca. 1900, watercolor on paper, 13 x 19 1/2 inches.
Collection of Oscar and Trudy Lemer.

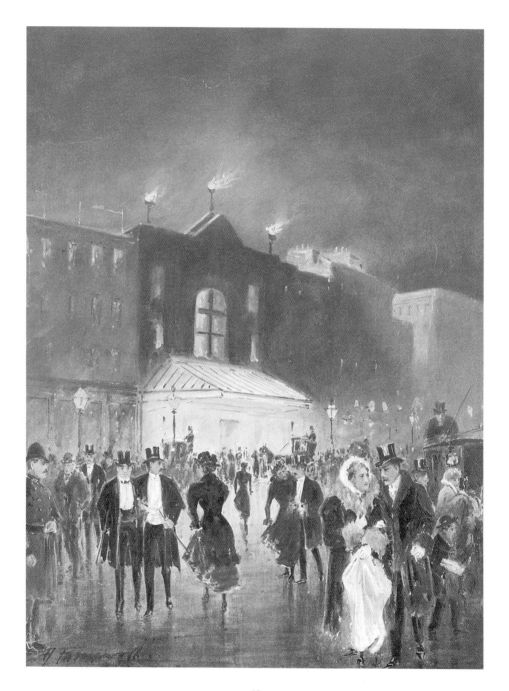

41

 THOUSAND ACRES of blowing sand dunes extending west to the Pacific Ocean were set aside in 1868 by San Francisco supervisors to be developed as a great public park. This inhospitable site was eventually transformed with plantings of trees, shrubs, and flowers; broad meadows; sculptured lakes and pools; along with winding roads, rustic bridges, and a minimum of intrusive structures.

Golden Gate Park remains today an immensely popular place of recreation, as it has for generations of San Franciscans and tourists. Attractions that include the Japanese Tea Garden, the Conservatory of Flowers, the Arboretum, two art museums, and a science museum with aquarium, are set among the various spectacles of nature. It is one of the finest urban parks in the nation.

Charles Griffin Farr visited the park almost daily for many weeks in preparation for this painting. His scene of children playing beside a tranquil reflecting pool surrounded by lush greenery effectively showcases the park's intended function as a natural refuge from the crowded urban environment, a glimpse of which is visible beyond the trees in the background.

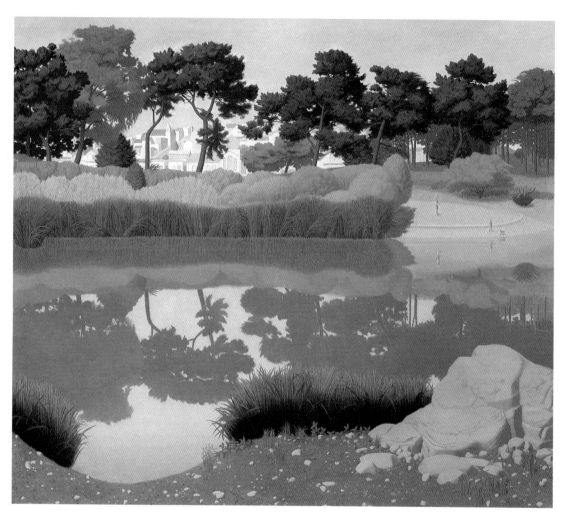

LAKE IN A CITY PARK
Charles Griffin Farr, 1976, oil on canvas, 34 1/2 x 47 inches.
Collection of Barrie Elise Carmel.

ESIDENTS OF Potrero Hill enjoy the best weather in the city—and some of the best views of downtown San Francisco and the bay. Situated southeast of the main business district, Potrero Hill was home to many Russian immigrants who fled the Czarist regime in the early years of the twentieth century. Potrero Hill remained sparsely settled until after World War II; a few residents still kept cows, goats, and chickens in this almost rural environment.

After the war, San Francisco artists and writers discovered the advantages of living on the hill, including low-cost housing and studio space. Today, Potrero Hill is a very appealing residential neighborhood though real estate developers have added multi-unit apartments and condominiums to the rows of charming Victorian cottages.

Charles Griffin Farr's *The Cocktail Hour* shares a quiet moment in contemplation of the view from the artist's dining-room window on Potrero Hill as the late afternoon sun illuminates pastel-colored buildings. Farr, born in 1908 in Alabama, studied with George Luks in New York and with Jean Despujols in Paris before settling in San Francisco where he continues to apply his "magical realist" approach to painting figurative, landscape, and still-life subjects.

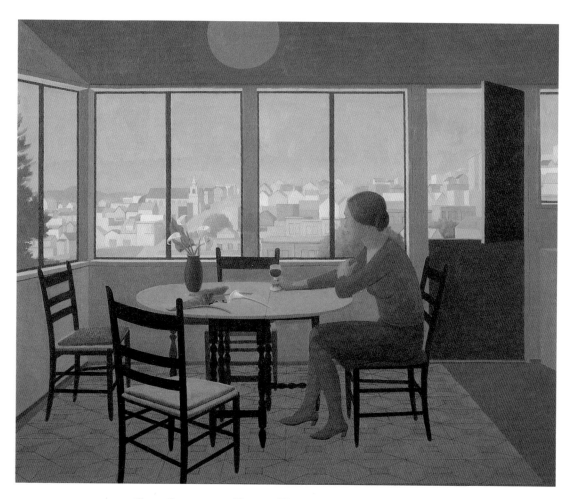

THE COCKTAIL HOUR (VIEW OF POTRERO HILL)
Charles Griffin Farr, 1990, oil on canvas, 30 x 36 inches.
Courtesy of Campbell-Thiebaud Gallery, San Francisco.

HE 1920S HERALDED a period of optimism and growth in San Francisco that was manifested throughout the city. The streets were transformed by the construction of tall buildings, by the growing numbers of automobiles, by the multiplication of colorful signs and advertisements, and by the gathering web of telephone wires and poles—all of which make up the image of a modern urban landscape.

One of the city's artists who came alive in this dynamic environment was Yun Gee (1906–1963). Born in a village near Canton, China, where he studied traditional Chinese painting, Yun Gee had demonstrated a radical preoccupation with western ideas before he arrived in San Francisco in 1921.

Gee soon settled in the city's Bohemian quarter bordering Chinatown, where he began associating with some of San Francisco's most progressive painters and poets. At the California School of Fine Arts, Yun Gee studied under Otis Oldfield who had been much influenced by the modernists during his fifteen years in Paris.

In his enthusiasm for modern art, Yun Gee organized the Chinese Revolutionary Artists' Club in 1926 to teach "advanced western painting" to Chinatown's young artists. Gee's *San Francisco Chinatown* represents an attempt to synthesize Chinese tradition with modernism using a theory of color and form he called "Diamondism."

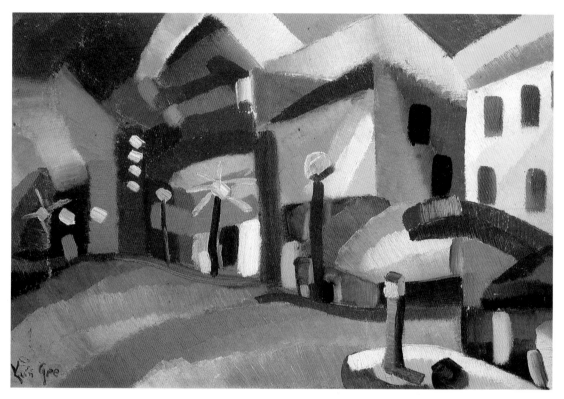

S a n F r a n c i s c o C h i n a t o w n
Yun Gee, 1927, oil on paperboard, 11 x 16 inches.
Collection of The Oakland Museum (Gift of Mrs. Frederick G. Novy).
Photo by M. Lee Fatherree.

*S*ANSOME STREET TODAY is in the heart of San Francisco's busy financial district, a canyon of high-rise office buildings that little resembles the 500 block depicted in William Hahn's market scene of 1872. Largely a wholesale district during the 1870s this congested area was a lively mixture of various commercial enterprises and Portuguese, French, and Italian vendors competing for spaces on the street to sell vast quantities of produce brought in from the surrounding countryside.

Beginning at dawn, carts loaded with fresh vegetables, fruits, fish, wild game, and dairy products were sold to storekeepers, restaurateurs, Chinese cooks, domestics, and housewives, who daily gathered along the crowded street. Numbered among the permanent businesses in the area were a brick kiln, print shops, a wholesale crockery importer, several bakeries, a saloon, and a coffee shop frequented by the diverse social and ethnic populations which defined San Francisco then as now.

William Hahn (1829–1887), a German-born artist trained at the Düsseldorf Academy, began a longtime residency in San Francisco in 1872 where he became California's foremost painter of genre scenes.

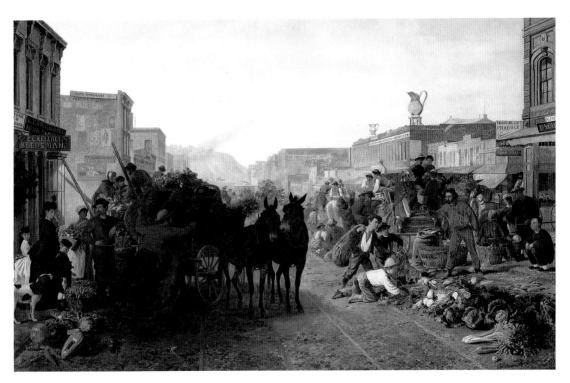

MARKET SCENE, SANSOME STREET, SAN FRANCISCO
William Hahn, 1872, oil on canvas, 60 x 96 inches.
Collection of the Crocker Art Museum, Sacramento.

W HEN THE PALACE HOTEL was opened in the 1870s, San Francisco could claim the most opulent lodging west of the Mississippi River— one worthy of kings and presidents. Within the grandeur of the hotel's majestic structure could be found every luxurious appointment and any extravagant hotel service required by these elite guests.

Befitting such an establishment, a chef of high repute was brought in to take charge of the kitchen. Jules Harder had twenty-six years of restaurant and hotel experience, including time spent at the famed Delmonico's in New York City. During his "reign" at the Palace, Chef Harder became the Pacific coast's undisputed authority on matters of food and wine and its proper service. He helped many prominent San Franciscans develop more sophisticated palettes and manners.

Joseph Harrington (1841–1890) was born in Ireland, but settled permanently in San Francisco in 1870, where he made his living as an artist and a teacher. His portrait of Jules Harder shows the distinguished chef with one of his culinary masterpieces, an aspic of langouste. The Palace Hotel was rebuilt on Market Street after the 1906 earthquake and fire, where it still stands today, recently refurbished, and now called the Sheraton Palace Hotel. Contemporary San Franciscans display justifiable civic pride in the city's reputation for fine restaurants and hotels.

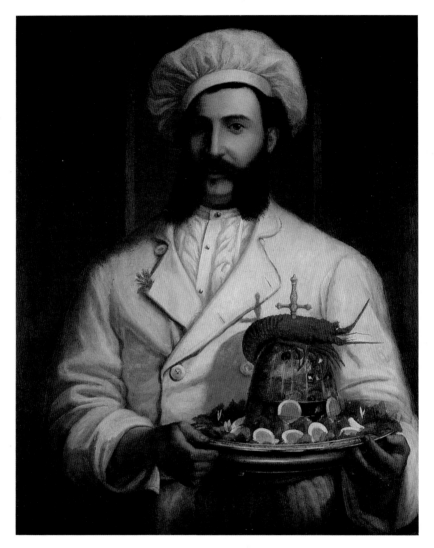

JULES HARDER, FIRST CHEF OF THE PALACE HOTEL
Joseph Harrington, 1874, oil on canvas, 36 x 29 inches.
Collection of The Oakland Museum (Gift of Mrs. Donald Hewlett and George Clark
in memory of George Casey Clark and Lydia J. Clark).

O N A ROCKY promontory west of the Golden Gate near San Francisco's Lincoln Park, where the continental land mass and the Pacific Ocean meet at Land's End, visitors can experience the exhilaration of a sea breeze and the salty spray it carries from the surf crashing on the rocks below. Land's End has long been a popular spot for romantic San Franciscans to witness this dramatic affirmation of the power of nature.

The briskly spontaneous brushstrokes of Thomas Hill's painting, *Land's End*, successfully capture the magic of this enduring attraction. Thomas Hill (1829–1908) was one of California's most prolific and popular artists in the nineteenth century. He earned the sobriquet "Painter of Yosemite," for his striking views of Yosemite Valley, where he maintained a studio for many years. Born in England and trained in Germany, Hill finally made California his permanent home. He specialized in panoramic scenes and majestic landscapes which he painted from sketches he made during frequent visits to picturesque sites all over the American West.

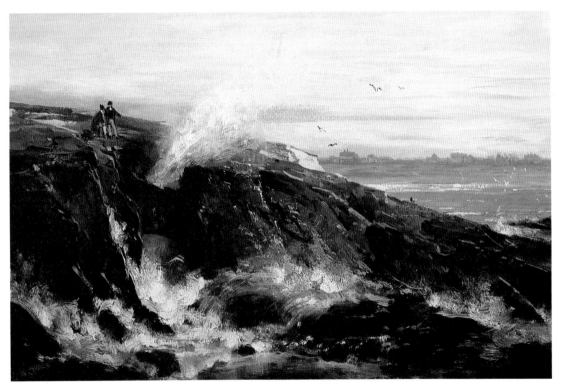

LAND'S END, SAN FRANCISCO
Thomas Hill, not dated, oil on canvas (mounted), 15 1/10 x 22 inches.
Collection of The Oakland Museum (Gift of Grace Decker Meyer in memory of her husband,
Victorian Melville Meyer). Photo by M. Lee Fatherree.

THE EMBARCADERO, which curves around the San Francisco waterfront, was for many years the heart of the city's thriving maritime industries. In the early part of this century it was a thoroughfare—200 feet across—bustling with the activities of sailors, longshoremen, and the workers in saloons, hotels, and bordellos which catered to the needs of a large waterfront clientele. The little Beltline Railroad carried cargo along the docks, contributing to the colorful sights and sounds.

After the decline of the maritime trade on the San Francisco side of the bay, a double-deck concrete freeway was built above the Embarcadero, blocking views of the waterfront and compromising the romantic spirit of this historic district. The controversial freeway, damaged in the 1989 earthquake, was demolished in 1991 and will be replaced by an underground or surface roadway.

John Langley Howard, born in 1902, is the youngest son of a prominent Bay Area family of artists and architects. He began his long career as a painter of the American scene, but now concentrates on mystic evocations of nature. In the 1930s, his strong social conscience led him to paint sympathetic images of working-class people striving to survive the Great Depression.

Howard's *Embarcadero and Clay* depicts a group of unemployed workmen whose purposeful stride is reinforced by the message "Confidence" emblazoned on the billboard. A well-dressed man with a briefcase is seen looking over his shoulder apprehensively as he steps up onto the curb. The scene is charged with the drama of imminent confrontation symbolic of the socioeconomic struggle of the time.

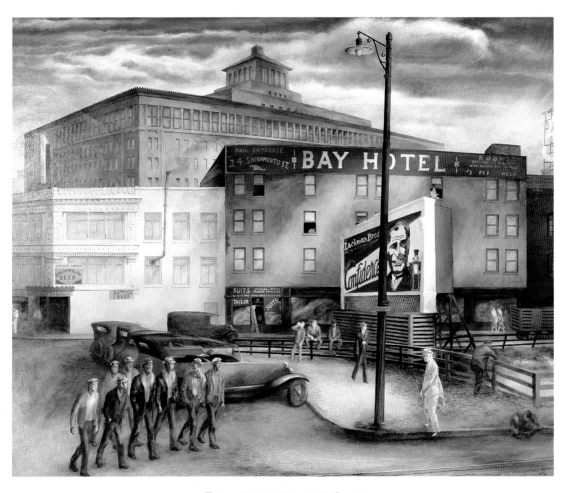

EMBARCADERO AND CLAY
John Langley Howard, ca. 1936, oil on canvas, 35 7/8 x 43 1/2 inches.
Collection of Mr. and Mrs. Norman Lacayo.

*T*HE VARIOUS LAYERS of San Francisco's history are most evident in the area situated between Telegraph Hill and the Financial District at the edge of Chinatown. Bronze plaques identify some of the city's oldest buildings. These older buildings are frequently wedged between contemporary skyscrapers—many of which were built atop the buried remains of gold-rush ships.

Yvonne Jacquette's composition, dominated by Coit Tower and a portion of the Transamerica pyramid, offers an aerial view of the district at night. This elevated point-of-view is almost directly above that taken by George Burgess in his depiction of San Francisco in July of 1849.

Night transforms the city. The solid steel, concrete, and glass of daylight seem to give up their weight and mass to the dark voids between floating dots and lines of electric light emanating from windows, automobiles, street lamps, and neon signs.

Jacquette (b. 1934) is a New York artist known for her panoramic depictions of landscapes observed from the windows of airplanes, and for her breathtaking night visions of American cities.

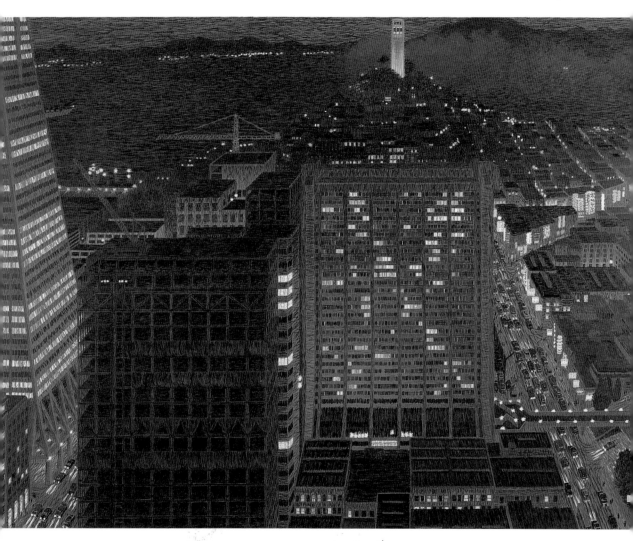

TELEGRAPH HILL II
Yvonne Jacquette, 1984, oil on canvas, 77 3/4 x 105 inches.
Courtesy of John Berggruen Gallery, San Francisco.

S A LITTLE GIRL, Lillie Hitchcock—who loved to chase fires—had been made an honorary member of her favorite fire house, Engine Company No. 5. Even after she was married to Howard Coit, in whose memory Coit Tower was erected, she idiosyncratically always signed her name, "Lillie Hitchcock Coit 5." It has even been suggested that her gift to San Francisco of the art-deco style tower, on the highest point of Telegraph Hill, resembles the nozzle of a fire hose.

Coit Tower was designed by Arthur Brown, Jr., who also designed the Civic Center, Sproul Hall on the Berkeley campus of the University of California, and a cluster of federal buildings in Washington, D.C. The impressive interior of Coit Tower is decorated with WPA-sponsored murals in fresco painted by a number of San Francisco's prominent artists. Some of the images in the panels reflected radical social criticism of the depression era with depictions of the unemployed, the strikers, and certain references to communism that sparked a scandalous political controversy, delaying the public opening of the tower in 1934.

Oakland native Dong Kingman (b. 1911) developed his watercolor style as a synthesis of Oriental heritage and Occidental realist training. Kingman depicts Coit Tower from a vantage at the base of Telegraph Hill, as it might be seen through a tracery of telephone wires and lamp posts. In the early years of San Francisco, the east side of the hill was blasted away to provide rocks used as ships' ballast. The pattern of construction betrays treacherous terrain: flights of wooden stairs zig-zag the precipitous hillside; footbridges cross little gullies eroded into the cliff, connecting houses with their gardens.

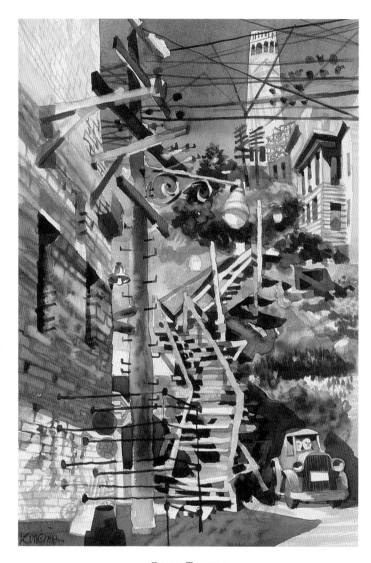

Dong Kingman, ca. 1949, watercolor on paper, 22 3/8 x 14 7/8 inches.
The Buck Collection.

59
THE PAINTED CITY

*B*EFORE THE BRIDGES opened in 1936 and 1937, the Ferry Building served as gateway to San Francisco from the north and east, receiving as many as fifty million passengers a year. The original wooden structure built at the foot of Market Street in 1875 was replaced by the present Ferry Building in 1898. Its landmark tower, modeled after the Giralda Tower of the Cathedral of Seville, weathered both the 1906 and 1989 earthquakes virtually undamaged.

Mexican-born painter Xavier Martinez (1869–1943) studied first in San Francisco and then in Paris in the 1890s, where he embraced a flamboyant Bohemian lifestyle which he sustained upon his return to the Bay Area. Martinez's studio on Montgomery Street, adjacent to San Francisco's notorious Barbary Coast district and the present site of the Transamerica pyramid, was the center of the city's avant garde culture before the great earthquake and fire of 1906. After that, Martinez built his studio across the bay in Piedmont and began his career teaching at the California College of Arts and Crafts in Oakland.

The Ferry Building must have been a familiar sight to Martinez, whose early evening view of it is taken from the fan-tail of a departing ferry boat which leaves its moonlit wake on the bay. The soft muted tones evoke a poetic mood that is typical of the beloved artist's style.

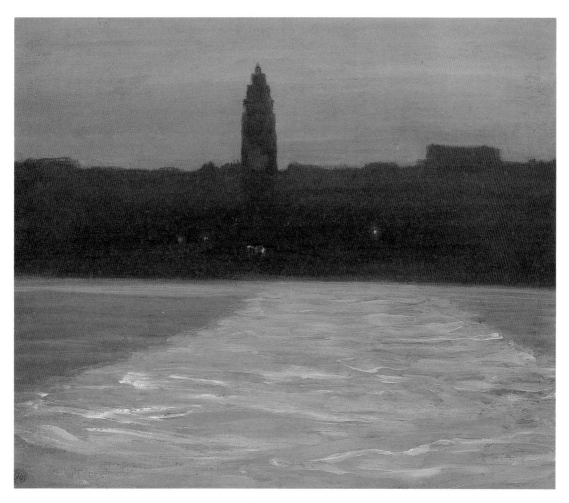

FERRY BUILDING, SAN FRANCISCO
Xavier Martinez, ca. 1910, oil on canvas, 20 x 24 1/2 inches.
Collection of The Oakland Museum (Gift of Miss Laetitia Meyer).
Photo by M. Lee Fatherree.

RIOR TO THE great earthquake, San Francisco had invited the renowned planner, Daniel Burnham, to work out a new blueprint for the growing city. An active period of reconstruction presented the perfect opportunity to implement Burnham's grand plan for an elegant neo-Baroque design of broad parkways and boulevards, temple-like public buildings, and terraced gardens with fountains that would harmonize with San Francisco's climate and topography. Ultimately, factionalized arguments within the business community caused the city to be rebuilt along pre-earthquake lines. But with the support of San Francisco's ebullient mayor, "Sunny Jim" Rolph, the impressive Civic Center—with its city hall, library, museum, auditorium, and opera house—was built with Burnham's utopian ideals in mind.

Arthur F. Mathews (1860–1945), San Francisco's dominant artistic influence at the time, also attempted to affect the shape of the new city with his own designs based upon Beaux Arts models. He placed these ideas before the public in a small magazine called *Philopolis* that was devoted to art and city planning.

Recognized as a master decorative artist, Mathews was called upon to create several murals for important public buildings around San Francisco and for the State Capitol in Sacramento. One of the twelve panels he painted for the capitol rotunda—each depicting different epochs in the history of California—was his view of San Francisco as a modern city. Mathews's 1913 *Sketch for the Modern City* is not futuristic so much as it is an idealized neo-classical concept of San Francisco, with skyscrapers topped by cathedral roofs and hemispheric domes rising above swirling clouds of fog.

THE MODERN CITY
Arthur F. Mathews, 1913, watercolor and pencil on paper, 27 7/8 x 21 inches.
Collection of the Santa Barbara Museum of Art (Gift of Harold Wagner).

*D*URING A TEN-MONTH period in 1915 the whole world was invited to San Francisco to celebrate the city's recovery from the earthquake and to commemorate the opening of the Panama Canal. The Panama-Pacific International Exposition was probably the most beautiful and successful of all the world's fairs despite the fact that it commenced at the time when much of Europe was already engaged in World War I. Twenty-eight nations and thirty-two states participated in the creation of an idealized, albeit temporary, "City Beautiful" located on 635 acres at the edge of San Francisco Bay in what is now known as the Marina district.

The P.P.I.E. was a triumph of harmonious civic planning conceived by some of the nations' most prominent artists and architects. Its classically inspired palaces and murals, archways and courtyards, fountains and sculptures were all constructed of artificial travertine and set among symmetrical gardens and reflecting pools.

San Francisco artist Lucia K. Mathews (1870–1955) made frequent visits to the exposition grounds carrying small wood panels on which she recorded in oils her direct observations of the wonderful sights. *Festival Hall* reveals the distinctive color scheme, created by artist Jules Guerin, that was used throughout the exposition. Festival Hall hosted many cultural programs, concerts, and recitals, including performances by celebrated composers Camile Saint-Saens and John Philip Souza presenting their own works specially commissioned for the P.P.I.E.

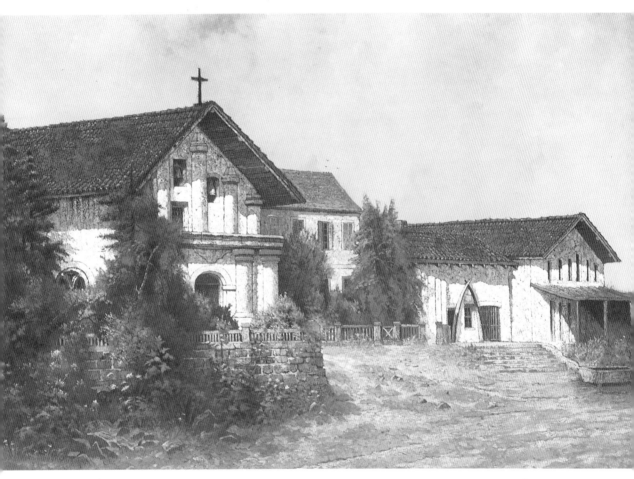

FESTIVAL HALL, PANAMA PACIFIC INTERNATIONAL EXPOSITION
Lucia Kleinhans Mathews, 1915, oil on wood panel, 5 7/8 x 3 7/8 inches.
Collection of The Oakland Museum (Gift of Harold Wagner).
Photo by M. Lee Fatherree.

THE CENTER OF banking and finance on the west coast resides in San Francisco's Financial District. Where gold rush ships once docked (before that portion of the bay was filled in), now stand monuments to twentieth-century capitalism: the world headquarters of the Transamerica Corporation, the Bank of America, other multi-national conglomerates, and the Pacific Stock Exchange.

Larry Morace's painting, composed as a view through the window of a moving automobile, reveals a narrow canyon of high-rise office buildings along a street defined by the strong, dark shadows of the late afternoon sun. The artist (b. 1948) has rendered the scene in broad, expressively distorting brush strokes that impart a sense of motion and perhaps also the stressful mood familiar to commuters in that part of the city.

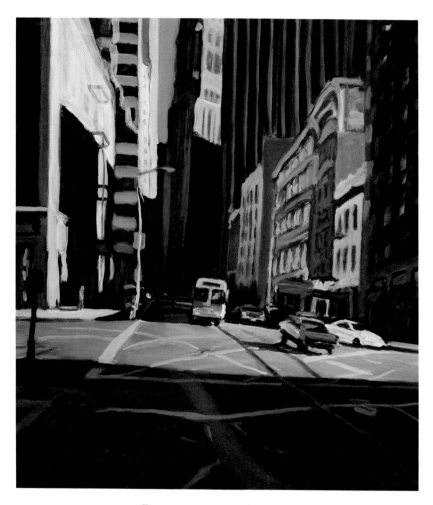

FINANCIAL DISTRICT #2
Larry Morace, 1988–91, oil on canvas, 64 x 55 1/2 inches.
Courtesy of Harleen and Allen Fine Art, San Francisco.

A T THE PEAK of gold fever during the early 1850s, while more than 800 passenger ships were left to sink or rot in the San Francisco harbor, a growing number of merchant ships arrived to bring supplies. The need for storage facilities grew at a faster pace than the new construction of warehouses, so some of the abandoned ships were temporarily put to use.

On July 24, 1853, the two storeships, *Canonicus* and *Manco*, berthed at the end of Sacramento Street wharf, caught fire. Valiant members of the San Francisco Fire Department rowed their boats out from the wharf to quench a blaze that threatened powder kegs aboard the *Manco*, as a nearby eyewitness sketched details of the scene on a box top.

In 1856 the Nahl brothers, in a rare collaboration, used the sketch as a basis for this dramatic painting. Charles Christian Nahl (1818–1878) and his half-brother, Hugo Wilhelm Arthur Nahl (1833–1889), were born into a family of artists in Germany. They both studied at the Cassel Academy and were among the first professionally trained artists to settle in California. Their vivid paintings provide enduring images of the gold rush years.

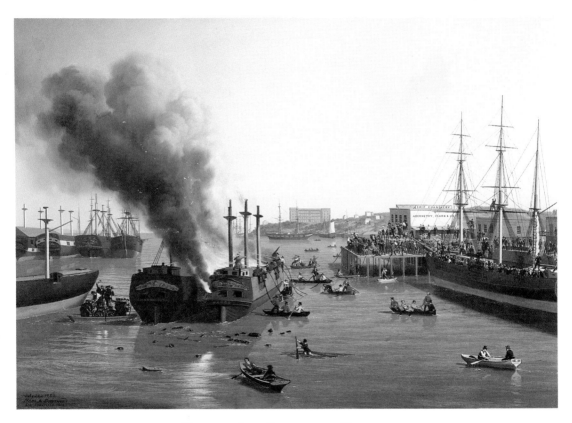

FIRE IN SAN FRANCISCO HARBOR
Charles Christian Nahl and Hugo Wilhelm Arthur Nahl, 1856, oil on canvas, 26 x 40 inches.
Collection of Fireman's Fund American Insurance Companies, San Francisco.
Photo courtesy of Montgomery Gallery, San Francisco.

T HE STRYBING ARBORETUM and Botanical Gardens, located on seventy acres in Golden Gate Park, is a living botanical museum featuring more than six thousand varieties of plants and trees blooming according to their seasons.

Officially opened to the public in 1940, its spacious informal setting of well-tended planting beds displayed along numerous pathways invites visitors to enjoy the beauty of the gardens at their own pace. With collections of native California plants and the many imported species that adapt well to San Francisco, climate-grouped in appropriate settings, the arboretum offers both inspiration and information to the amateur horticulturalist or landscape gardener.

Peter Nye (b. 1954), a contemporary realist painter in San Francisco, depicts a sunny corner of the arboretum with vigorous descriptive brushstrokes that suggests a garden scene painted *en plein air*.

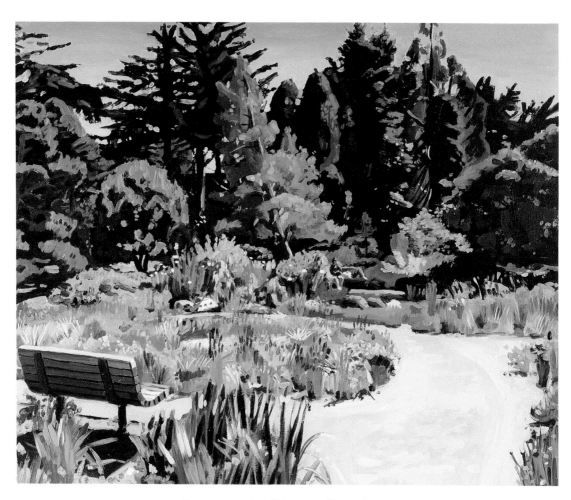

ARBORETUM, GOLDEN GATE PARK
Peter Nye, 1989, oil on canvas, 20 x 24 inches.
Collection of Mr. and Mrs. Mordechai Winter.
Photo courtesy of Contemporary Realist Gallery, San Francisco.

\mathscr{L}OCATED IN THE northeast corner of San Francisco, adjacent to maritime enterprise on the bay, Telegraph Hill is part of an area known as North Beach, bordered on the south by Chinatown and the once notorious Barbary Coast.

Many working-class families of the city's rapidly growing Italian-American community came to live in the little cottages clinging to the steep slopes of Telegraph Hill during the early years of the twentieth century. With its Mediterranean-type climate and its close proximity to Fisherman's Wharf the hill reminded Italian immigrants of home. By 1930, one in ten San Franciscans were of Italian descent, making them the largest of the city's national groups.

During the depression, Telegraph Hill also provided low-cost housing for many of the city's artists who gravitated toward the North Beach way of life. Otis Oldfield (1890–1969), who was born in Sacramento and who lived in Paris from 1911 to 1924, was one of San Francisco's most respected artist-teachers in the 1930s and 1940s. In 1927, Oldfield painted this lively neighborhood scene from his studio overlooking the bustling Embarcadero.

TELEGRAPH HILL
Otis Oldfield, 1927, oil on canvas, 40 x 33 1/4 inches.
The Delman Collection.

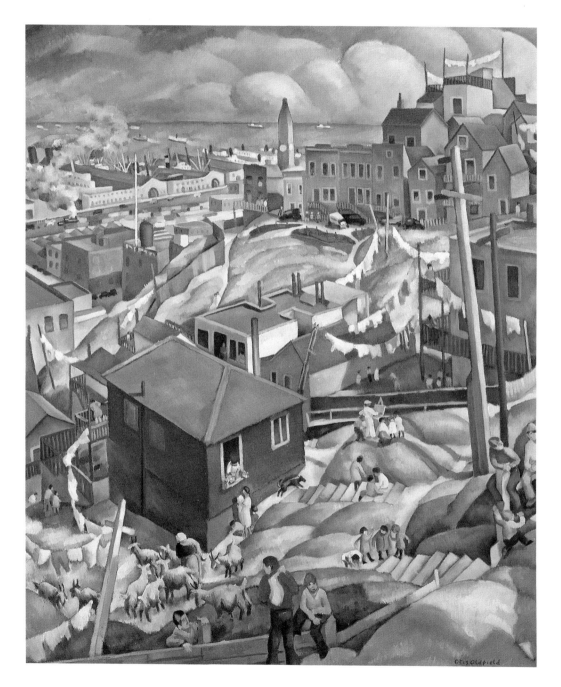

73

THE PAINTED CITY

D

URING THE TWO decades following World War II, San Francisco was second only to New York as a center of jazz musicianship. Guest stars mixed with local musicians; progressive, traditional, and Dixieland styles were performed for enthusiastic audiences at more than a dozen spots all over the city.

At that same time, some of San Francisco's visual artists showed interest in progressive, improvisational approaches to abstract painting that had certain parallels with jazz music. During the mid-1940s, an outstanding group of visual artists from both California and New York came to teach at what is now the San Francisco Art Institute, and drew national attention to the local Abstract Expressionist painters.

The history of the art institute goes back to 1871, making it the oldest school of the visual arts in the West. David Park (1911-1960) was among the first Abstract Expressionist painters teaching at the art institute to abandon abstract painting in favor of a return to recognizable figurative subject matter, leading the first generation of painters into the famous Bay Area Figurative Movement.

One of the school's innovations, contributing to its renaissance in the forties, was the creation of the Studio 13 Jazz Band made up of a number of artist players—then including David Park. The enthusiasm of its alumni has kept the amateur band active to the present day. *Rehearsal* depicts the Studio 13 Jazz Band, with David Park on piano.

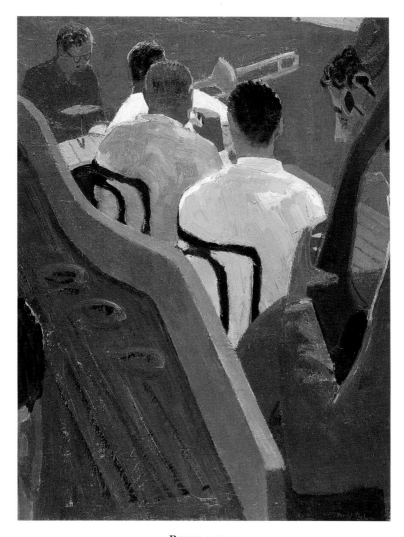

REHEARSAL
David Park, ca. 1949–50, oil on canvas, 46 x 35 3/4 inches.
Collection of The Oakland Museum (Gift of the American Federation of Arts).
Photo by M. Lee Fatherree.

*T*N SAN FRANCISCO'S early days, when Fisherman's Wharf lived up to its name—no restaurants, no art galleries, no tourist shops—it had been located in various places near the base of Telegraph Hill. Today's wharf, at the end of Taylor Street, is radically different from the one depicted by Charles Rollo Peters in 1885.

The picturesque *feluccas*, Mediterranean-type fishing boats rigged with triangular sails, were favored by Italian fishermen. Once a familiar sight on the bay, they supplied San Franciscans and the commercial canneries with fresh fish, shrimp, and crab taken from nearby waters in the open sea, the bay, and the Sacramento and San Joaquin rivers. After 1900, fishermen began replacing their sailboats with craft propelled by gasoline engines. Now, sadly, the local waters have become depleted and the fishing industry is in decline. Still, in the early-morning hours, along the wharves where the rows of boats are moored, Italian voices can be heard across the water echoing the romantic history of this tourist attraction.

Peters (1862–1928), was born in San Francisco. He studied art both at home and in Paris before establishing a successful studio on his Monterey estate. There he painted the dark romantic nocturnes of adobes in the moonlight for which he is best known.

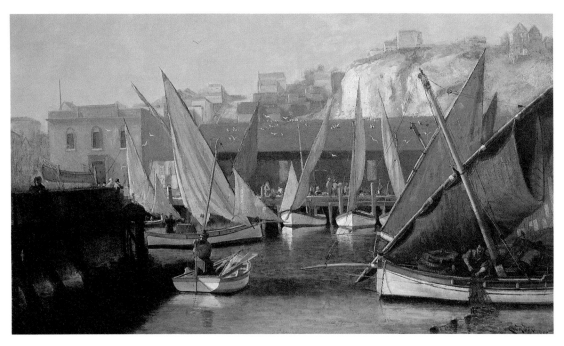

FISHERMAN'S WHARF
Charles Rollo Peters, 1885, oil on canvas, 22 1/2 x 36 1/2 inches.
Collection of Dr. Albert Shumate, San Francisco.
Photo by M. Lee Fatherree.

*L*ONG AGO A portion of the bay was filled in to eliminate the actual North Beach in the San Francisco district that bears its name. With its overlapping Italian and Chinese communities that also included large numbers of French, Portuguese, and Mexican residents, North Beach was San Francisco's Latin Quarter. This stimulating cultural milieu appealed to painters, poets and authors who frequented the district's many cafés, bars, and delicatessens to taste the intensity of cosmopolitan life.

The sound of fog horns and the fragrance of sea breezes mingled with aromas emanating from flower stalls, coffee roasters, fish markets, and sourdough bread bakeries—all contribute to the special character of North Beach neighborhoods. In *Blue Monday*, Oakland watercolorist George Post (b. 1906) provides a laundry-day perspective from a rooftop above Washington Square that shows the twin spires of Saints Peter and Paul church, and, in the distance, the Golden Gate Bridge.

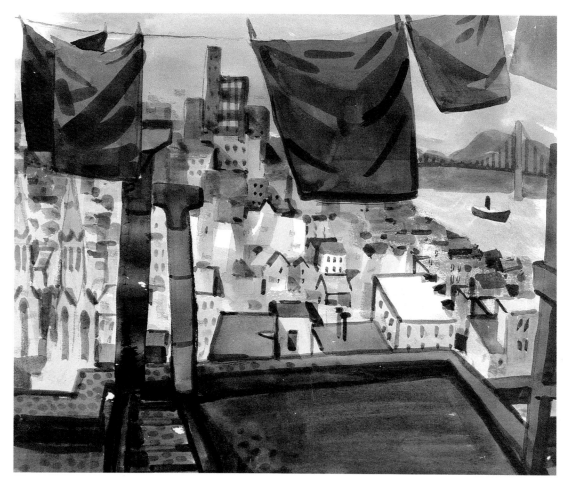

BLUE MONDAY
George Post, 1940, watercolor on paper, 15 x 18 inches.
The Buck Collection.

*S*AN FRANCISCO'S favorite family amusement resort on any Sunday afternoon before the turn of the century was Woodward's Gardens, located in the Mission District. Originally it was the private home of Robert Woodward whose popular What Cheer House was the city's first hotel to serve a la carte meals. He spent his fortune developing the extensive gardens and special attractions that delighted visitors for more than two decades.

Horse-drawn rail cars brought families from all over the city to visit the zoo, the aquarium, and the sea-lion pond; to be thrilled by the balloon ascensions or the shows in the entertainment halls; to take pleasure in leisurely boat rides on the lakes or strolls through the botanical gardens. Higher cultural requirements were met in an art gallery featuring copies of old-master paintings.

At the age of twenty-one, Scottish-born painter Thomas Ross (1829–1896) arrived in San Francisco along with throngs of other gold seekers. His appealing paintings of gold mining subjects, Yosemite landscapes, and especially the San Francisco street scenes, have a naïve charm, with utter devotion to accurate details that betrays his lack of formal art training.

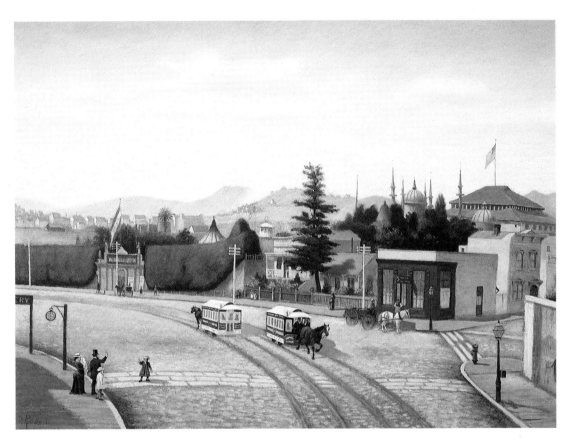

WOODWARD'S GARDENS, SAN FRANCISCO
Thomas Ross, 1886, oil on canvas, 20 x 27 inches.
The Delman Collection.

*I*TS TOPOGRAPHY HAS been compared to the seven hills of Rome, but in San Francisco there are more than forty. Instead of laying out the streets in deference to the steep terrain, early planners imposed a conventional grid upon the contours, insuring the city's distinctive appearance and more than a few complications brought on by the growth of automobile culture. When the downtown business district was rebuilt after the earthquake and fire in 1906, the architectural approach was conservative, informed more by nineteenth-century exemplars than by the emerging twentieth-century modernism. During the high-rise building boom of the 1960s, glass-walled structures of the international style began to replace some of the older buildings—hence the mixture of styles in evidence today.

Wayne Thiebaud's *Urban Square* captures the essential character of San Francisco's metropolitan center with its precipitous streets, its blend of architectural features, and perhaps most striking of all, its radiant midday atmosphere. Without reproducing an actual location in the city, Thiebaud, (b. 1920) has abstracted the familiar elements in a lively composition of angular patterns in vivid color, suggesting brilliant sunlight and deep shadows. His convincing scene could only be San Francisco.

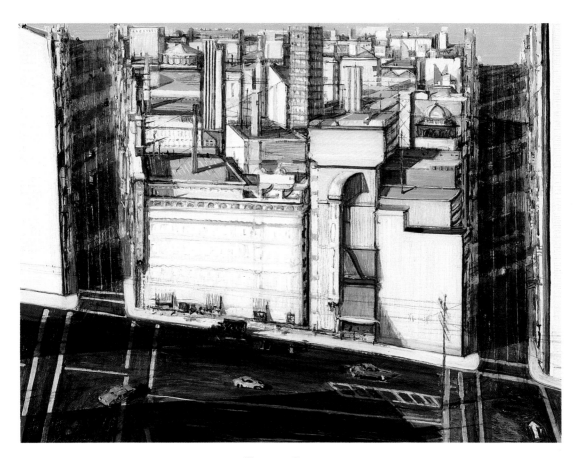

URBAN SQUARE
Wayne Thiebaud, 1980, oil on canvas, 36 x 48 inches.
Collection of The Oakland Museum (Gift of Dr. and Mrs. James B. Graeser).

*L*ONG REGARDED AS one of America's most romantic cities, San Francisco has often inspired the authors, poets, painters, and songwriters of the world whose works celebrate the dramatic, the exotic, the nostalgic, or the sublime qualities and moods found in the colorful life of the city. When framed by San Francisco's distinctive features, the great spectacle of nature in its various dispositions becomes metaphorically potent.

Paul Wonner (b. 1920) was an important contributor to the Bay Area Figurative Movement from the 1950s to the mid-1960s. In recent years he has concentrated on still-life and landscape subjects. *View with Red Sun through Dark Clouds* is one of twenty-seven studies for a romantic view of San Francisco undertaken by Wonner in 1980. His lurid sunrise view, from high above Market Street—the north-south dividing line of both the city and the painting—suggests a somewhat apocalyptic outlook for the great City by the Bay.

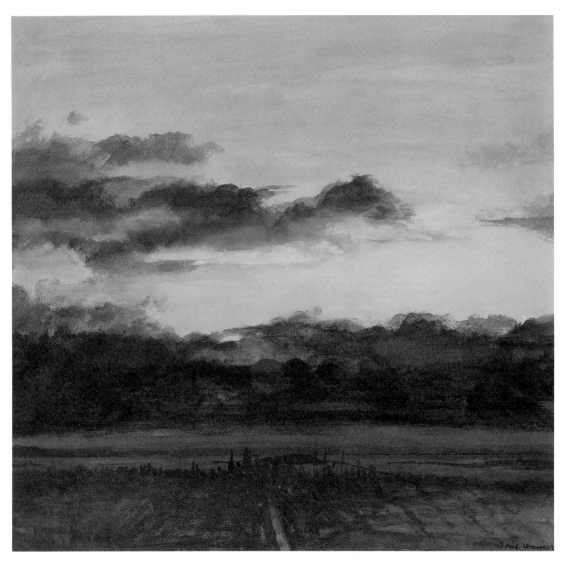

VIEW WITH RED SUN THROUGH DARK CLOUDS #16
(FROM 27 STUDIES FOR ROMANTIC VIEWS OF SAN FRANCISCO)
Paul Wonner, 1980, acrylic on paper, 17 x 18 inches.
Courtesy of Campbell-Thiebaud Gallery, San Francisco.

 CITY WITHIN A CITY, San Francisco's Chinatown blends modern architectural façades with tiled pagoda roofs on busy streets that claim the largest Chinese population outside Asia.

The Chinese came first during the gold rush to do manual labor in the mines; later, still more came to build the railroads across the Sierra Nevada range. After the transcontinental railroad was finished in 1869, many of the workers flocked to San Francisco where they settled in the city's Chinese quarter. There they opened businesses and shops that included markets, restaurants, bakeries, laundries, and arts and antiques emporia, creating a self-sufficient world based upon Chinese customs. As a result of strong anti-Chinese sentiment that grew among San Francisco's other populations, who believed that the Chinese were taking jobs from them during tough economic times, Chinatown had become a crowded, isolated community by the late-nineteenth century.

As a boy, San Francisco artist Theodore Wores (1859–1939) became interested in sketching the apparently exotic activities of Chinatown. Following his formal art studies in San Francisco and Munich, Wores became one of the first western painters to visit Asia. His street scene, *New Year's Day in San Francisco Chinatown*, depicts children dressed in their finest ethnic attire buying branches of flowering quince or pots of blooming narcissus bulbs to symbolize the regeneration of life that is part of their traditional New Year's celebration.

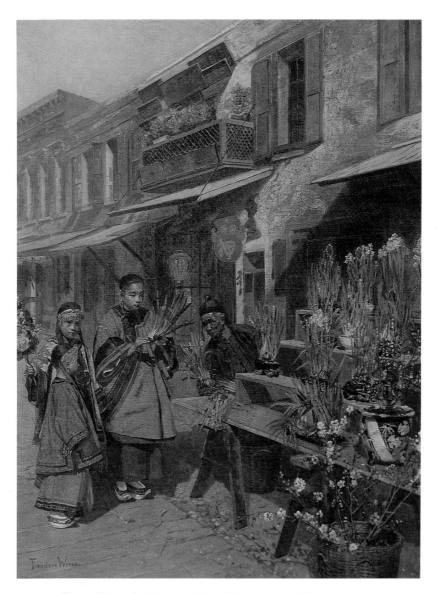

NEW YEAR'S DAY IN SAN FRANCISCO CHINATOWN
Theodore Wores, 1881, oil on canvas, 29 x 22 inches.
Collection of Dr. Ben Shenson and Dr. A. Jess Shenson, San Francisco.

ACKNOWLEDGMENTS AND ADDITIONAL CREDITS

The author and publisher wish to thank the galleries, museums, collectors, and artists who helped us gather these paintings. In the credit lines, the phrase "courtesy of . . ." is generally used to acknowledge the party from whom we obtained a reproducible transparency, if different from the copyright holder or owner of the painting.

We extend special thanks to the contemporary artists, who have generously allowed their works to appear, and who continue to create memorable images of one of America's great cities.

The short quote on the back of the dust jacket is from John Steinbeck's book, *Travels with Charley in Search of America* (© 1962). The verse on the front flap appears on a bronze plaque erected in 1978 at the dedication of Robert Frost Plaza where California Street meets Market.

Ina Coolbrith, whose poem, "San Francisco," serves as an epigraph for this book, was California's first poet laureate, indeed the first poet laureate named in the United States. The verses were written on the occasion of the 1906 earthquake.

Current volumes in the Painted City series include *New York*, *San Francisco*, and *Minneapolis/St. Paul*. Future books about the paintings and history of Los Angeles, Chicago, Philadelphia, and other American cities are also planned. Contact the publisher at (801) 544-9800 or toll-free (800) 421-8714 for more information.

Gibbs M. Smith, Publisher
Heather Bennett, Editor
Dawn Valentine, Editorial Assistant
Kathleen Timmerman, Designer